OF THE·JUST SHAPING OF LETTERS
BY ALBRECHT DÜRER
TRANSLATED
BY
R.T.NICHOL
FROM THE LATIN TEXT OF
THE EDITION OF
MDXXXV

OF THE JUST
SHAPING OF
LETTERS

FROM THE APPLIED
GEOMETRY OF
ALBRECHT
DÜRER
BOOK
JJJ

DOVER PUBLICATIONS, INC. • NEW YORK

Published in Canada by General Publishing Company, Ltd., 30 Lesmill Road, Don Mills, Toronto, Ontario.

Published in the United Kingdom by Constable and Company, Ltd., 10 Orange Street, London, W.C. 2.

This Dover edition, first published in 1965, is an unabridged and unaltered republication of the work first published by the Grolier Club in 1917.

International Standard Book Number: 0-486-21306-4
Library of Congress Catalog Card Number: 64-18848

Manufactured in the United States of America

Dover Publications, Inc.
180 Varick Street
New York 14, N. Y.

ALBRECHT DÜRER TO WILIBALD PIRCKHEIMER
HIS PATRON AND VERY GOOD FRIEND
GREETING:

IN our Germany, most excellent Wilibald, are to be found at the present day many young men of a happy talent for the Art Pictorial, who without any artistic training whatever, but taught only by their daily exercise of it, have run riot like an unpruned tree, so that unhesitatingly and without compunction they turn out their works, purely according to their own judgment. But when great and ingenious artists behold their so inept performances, not undeservedly do they ridicule the blindness of such men; since sane judgment abhors nothing so much as a picture perpetrated with no technical knowledge, although with plenty of care and diligence. Now the sole reason why

painters of this sort are not aware of their own error is that they have not learnt Geometry, without which no one can either be or become an absolute artist; but the blame for this should be laid upon their masters, who themselves are ignorant of this art. Since this is in very truth the foundation of the whole graphic art, it seems to me a good thing to set down for studious beginners a few rudiments, in which I might, as it were, furnish them with a handle for using the compass and the rule, and thence, by seeing Truth itself before their eyes, they might become not only zealous of the arts, but even arrive at a great and true understanding of them.

Now, although in our own time, and amongst ourselves, the Art Pictorial is in ill repute with some, as being held to minister incite‐ ment to idolatry, yet a Christian man is no more enticed to superstition by pictures or images, than is an honest man girt with a sword to high‐ way robbery. Certes he would be a witless creature who would willingly adore either pictures or images of wood or stone. On the contrary, a picture is the rather edifying and agreeable to Christian religion and duty, if only it be fairly, artificially, and correctly painted.

In what honour and dignity this art was anciently held amongst the Greeks and Romans, the old authors sufficiently testify; though afterwards all but lost, while it lay hid for more than a thousand years. It has now at length, only within the last two hundred years, by some Italians been brought again to light. For it is the easiest thing in the world for the Arts to be lost and perish; but only with difficulty, and after long time & pains are they resuscitated. Wherefore I hope that no wise man will defame this laborious task of mine, since with good intent & in behoof of all who love the Liberal Arts have I undertaken it: nor for painters alone, but for goldsmiths too, & for sculptors, and stonecutters, and woodcarvers, and for all, in short, who use compass, and rule, and measuring line—that it may serve to their utility.

Nor is anyone compelled whether or no to spend gainful hours on these exercises of mine; although I am not ignorant that whoever is well exercised in them will thence acquire not only the principles of his own art, but by daily practice, an exactitude of judgment, with which he will proceed to higher investigations & discover many more things than I have here pointed out.

But since, illustrious Sir, it is clearer than light that you are yourself,

so to speak, an asylum of all the noble Arts, it has been my pleasure, out
of a singular love I bear towards you, to dedicate to you this book; not
because I desire to appear therein as rendering you any great service,
but because thereby you may understand how engaged my mind
is to you; and since by my work I can confer on you but
little favour, at least by the exhibition of a ready
mind I may repay the benefits
you shower upon
me.

Farewell.

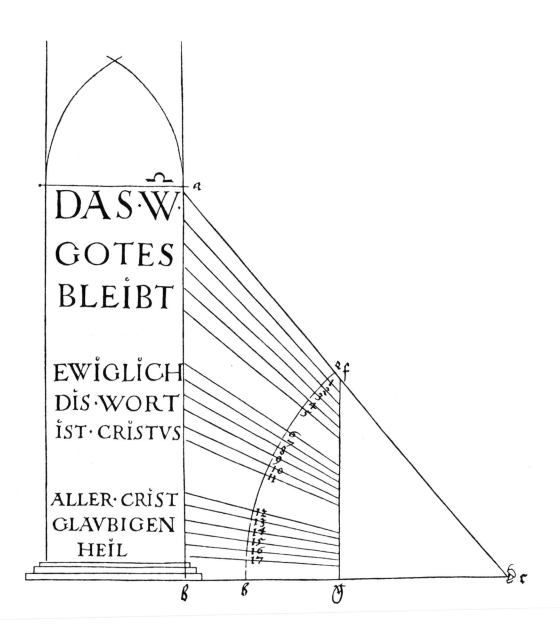

DAS·W·
GOTES
BLEIBT

EWÏGLÏCH
DÏS·WORT
ÏST·CRÏSTVS

ALLER·CRÏST
GLAVBIGEN
HEÏL

OF THE JUST SHAPING OF LETTERS

FROM THE APPLIED GEOMETRY
OF ALBRECHT DÜRER
BOOK III.

OW, since architects, painters & others at times are wont to set an inscription on lofty walls, it will make for the merit of the work that they form the letters correctly. Accordingly I am minded here to treat briefly of this. And first I will give rules for a Latin Alphabet, and then for one of our common Text: since it is of these two sorts of letters we customarily make use in such work; and first, for the Roman letters: Draw for each a square of uniform size, in which the letter is to be contained. But when you draw in it the heavier limb of the letter, make this of the width of a tenth part of the square, and the lighter a third as wide as the heavier: and follow this rule for all letters of the Alphabet.

First, make an A after this fashion: Indicate the angles of the square by the letters a. b. c. d. (and so do for all the rest of the letters): then divide the square by two lines bisecting one another at right angles — the vertical e. f. the horizontal g. h.: then, in the lower line, take two points, i. and k., distant respectively one-tenth of the space c. d. from the points c. and d.: then, from the point i. draw upwards to the top of the square the lighter limb; & thence downwards the heavier limb, so that the outer edges of both may touch, respectively, the points i. and k.: then let a triangle be left between the limbs, and a point e. be fixed at top in the middle of the letter, and next join both limbs beneath the horizontal line, and let this limb be a third as broad as the heavier limb.

Now let the arc of a circle, applied to the top of the outside edge of the heavier limb, project beyond the square. Then cut off the top of

the letter with a serpentine or curving line, so that the concavity de-
cline towards the lighter limb, and prolong acutely either limb of the
letter at the bottom to either side, so as to meet the angles of the square
at c. and d.: this you shall make with the arc of a circle, whose semi-
diameter is one-seventh of the side of the square; but the two lower
curves, mutually opposite, permit to extend so that each is a third of
the heavier limb, and this you shall obtain by the arc of a circle whose
diameter is equal to the breadth of the heavier limb.

Moreover, this same letter A you may cut off at top with the side
of the square, and then produce to a fine point in either direction, as
you did the feet below, yet so that the longer production shall be to
the fore-side (namely, the left); but in this case it will be necessary to
draw in the limb k. a little closer.

Likewise the same A you may draw in yet another manner—that is,
pointed at top. In that case let the limbs slope towards one another yet
more closely; then lower the transverse a little and double its width.
You may also cut off the limb at top bluntly, or sharpen it on the fore-
side. You ought to make yourself familiar with these three forms, or
whichever of them pleases you best.

And note likewise that in exactly the same fashion in which this
letter is acutely prolonged at top & bottom, are the other letters to be
so prolonged which are drawn with oblique lines, as V, X, Y, although
a few changes may be necessary, as you shall hear below.

I have here subjoined an engraving of this letter.

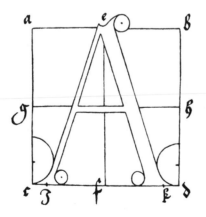
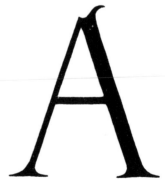

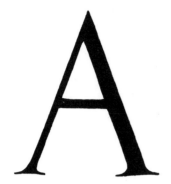 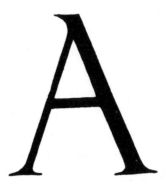

OF THE LETTER B.

And now you shall draw B in its square thus: First divide the square horizontally by the line e. f.; then bisect the lines a. e. and b. f. by the line g. h. Next, you must first set properly the broad vertical limb of the letter, distant its own breadth from the side a. c. of the square a. b. c. d. Then erect the line i. k. on the inner side of the limb already drawn, and distant from it one-tenth of a side of the square, and let it cut the line g. h. in the point l.

Next, draw strips narrower and horizontal (to be produced here-after into the convex limbs) from the vertical band to meet the vertical line i. k.—namely, at top, below the line a. b.; next, above the line e. f.; and at bottom, above the line c. d.

Now set a leg of the compass on the point l. and describe a semi-circle to the right of the transverse strips, so that the extremities of the circumference, in the vertical line i. k., below the side a. b., and above the line e. f. may coincide with those short transverse lines. Then bisect the narrow transverse strip which is above the line e. f. in the line i. k. by the point m.; and indicate the breadth of the letter, to the right of the semicircle, by the point n. in the line g. h.; and afterwards draw from the point m. above the line e. f. in the direction of f. a short horizontal line as great as need be: then describe a semicircle which shall include this line, and the point n., and, at the top, the side a. b.; and through n. let pass a vertical line. These all combine to form, below, the concave of the curved limb, and above, its convex.

Next, produce the transverse strip above c. d., in the direction of d.,

as far as required, and mark this q. Then bisect the line m. q. by the line o. p., cutting the line n. in the point r.; and next describe a semi⁄circle touching the horizontal line e. f., the point r., and the position q. Then indicate the breadth of this limb of the letter by the point s. to the right of the point r. in the line o. p. and describe a semicircle, touching the line m., the point s., and the side of the square c. d. There will then remain in the letter three right angles to be eliminated: the interior and lower one may be shaped into a curve by a circle whose semi⁄diameter is two⁄thirds of the breadth of the broad limb of the letter, and the exterior ones you shall fine to a point by circular lines whose semi⁄diameter is equal to the breadth of that limb.

Another method.

Or you may make your B in this fashion: Let the side a. c. of the square be divided into nine equal parts, and cut off the four superior parts by the horizontal line e. f. Then erect your vertical limb as de⁄scribed above; and the superior curved limb you shall make between a. b. and e. f.; the inferior between e. f. and c. d.

Now divide a. b. into nine equal parts, and cut off four parts towards b. in the point g.; then divide c. d. into five equal parts, and the last, towards d. mark off in the point h. and join g. and h. by the line g. h. which should touch on their exterior edges the superior and inferior limbs of the letter. Now these limbs must be drawn of a particular form; and the compass, in drawing the circular lines, must be moved up and down their diagonals: and these two diagonals you shall determine in this wise.

Divide a. e. into four parts; the lowest, above e., call i. e.; the lowest of the five remaining, above c., call c. k. Then join the points i. and b. and k. and f. respectively, by the lines i. b. and k. f. Upon these lines move and turn your compass, & in this way you shall describe both curved limbs: and they must both be broader towards the top than towards the bottom, as follows naturally with the stroke of a pen, and, more⁄over, while approximately round, they are not to be circular; therefore you will have to move your compass at need along the diagonals, and withal to assist it also with the hand, as I have done in the picture on the following page.

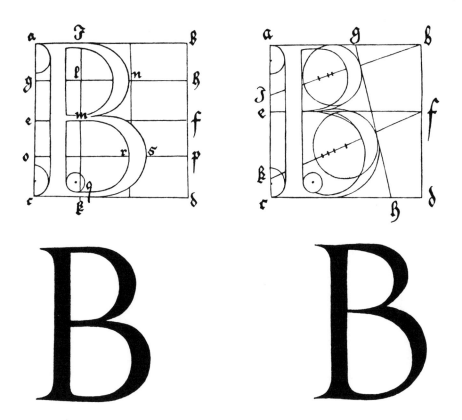

OF THE LETTER C.

Next you shall make the letter C in its own square thus: Bisect the square a. b. c. d. by the horizontal line e. f. and in it let i. be the middle point. From this point as the centre, & i. f. or i. e. as the radius, describe a circle touching interiorly all four sides of the square. Now move the leg of the compass, but without varying its span, to a point k. a little to the right of i. in the line e. f., letting the space i. k. denote the greatest breadth of the letter you desire; & from the centre k. describe another circle which shall cut twice the line b. d., and whose circumference to the left will mark the required breadth of the letter. Next, draw the vertical line g. h., parallel to b. d., distant from b. a tenth part of the line a. b. This will cut off for you at top and bottom the letter C as the an-cients were accustomed to use it. But I would have you cut off the lower limb in the middle point between g. h. and b. d.: then make the limbs somewhat finer and rounder on the inside towards top and bottom from the point where the circles intersect; and for its greater perfection

round out the letter, above and below, to touch the sides of the square a. b. and c. d. Next, low down, where the letter with one foot crosses the line g. h, there, under the circular line make the form a little more incurved, yet so that with the tip of its end it shall again touch the cir‑cular line. Similarly, but higher up, make the foot more hollow on the inside than the circle left it: and thus two circular lines will give you very nearly the whole form of the letter.

<div align="center">Another method.</div>

Or, secondly, you may make the letter C thus: Draw in the square a diagonal c. b.; set the leg of your compass on its middle point i. and with the other leg describe the exterior circle as before, terminating it above at the diagonal c. b.; but below, make your circle pass a little be‑yond the former sweep. Then set the leg of your compass, but without changing its gauge, as far above i. in the diagonal as the letter's greatest width, and describe your inner circle; and, as though made with a pen, let the descending stroke be heavier than the ascending. The rest you may elaborate with your hand; & let the trimming of the ends of the letter, above, slope upwards, & below, downwards, exactly as I have here drawn the shapes.

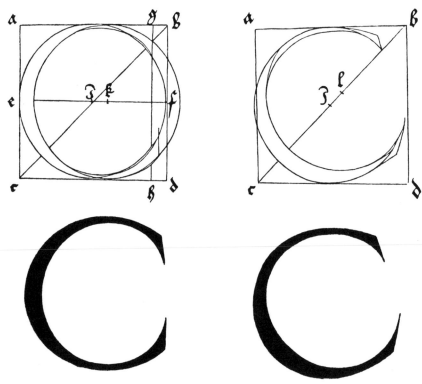

The letter D you shall make thus: Divide its square by the perpen-
dicular or vertical line g. h. and by the horizontal line e. f. into four
small squares, and call their point of intersection i.: then draw the
broader limb of the letter from the side a. b. downwards, to meet the
side c. d. and at the distance of its own width from a. c.; and produce
the limb at top and bottom to a sharp point at the angles a. and c. as
was shown above in B; using the same method in all straight limbs in
the remaining letters. Next you are to produce from this limb two
narrower tracts horizontally, and from these are to be described the
circular arcs of the letter between the line a. b. at top and the line c. d.
at bottom, and extending as far as the perpendicular g. h.; next, with
your compass join g. f. h. Then, in the line e. f. lay off a portion equal
in breadth to the widest limb of the letter, at the point k.; next, set one
foot of your compass on k. and let the other cut the said line e. f. in l.;
let this be the immovable leg of your compass, and with the other, be-
ginning from k., describe internally, to the narrower transverse limbs,
an arc which shall touch both, completing your acute angle above, but
rounding out the lower one by a circular arc of the same diameter as
the one by which you sharpened your exterior subtending angle.

Another method.

You may make the round limb of the same D in another fashion;
namely, as a pen naturally would, broader above than below. For this,
draw the diagonal c. b. and describe your exterior arc as before; but to
describe the interior, in the line c. b. take a point m. lower down than
i. and distant from it the width of the broader limb, and without alter-
ing your compass describe an interior line; but where the limb must
needs be narrower, there you are to accommodate it with your hand,
both below and above, as in the following cut.

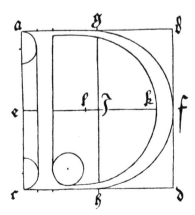
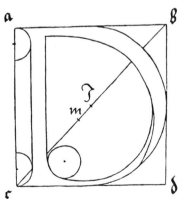

an arc upwards to the line a. b. so as to meet the perpendicular line g. h. & mark that point z. Then, in the line g. h., take a point m. so that the part m. h. shall be one⁄tenth of the line g. h.; then, with a sweep of your hand join l. & m. with the curved line l. m. Next, you are to draw from z. a line upwards, as broad as the standard of the letter, but oblique and in direction midway between your circular line & the perpendicu⁄lar g. h. and from the extremity of this line you must draw a curved line to meet a. b. at the point where your circular line touches it. Next, cut off from the bottom of g. h. a part one⁄third of its length, & indi⁄cate this by the point n., & to this height, from the level of m. upwards, produce the broad limb of the letter, and let its extremities above be finished in either direction, of the same size. After this set the leg of your compass on the diagonal c. b. the breadth of the standard of the letter above i. & at the distance e. i. describe an arc, which above shall touch the exterior boundary a. b. but below shall stop short above l.; & from this point you must with your hand draw a line to the vertical limb at the height of m.

And the same you shall do above in drawing the narrower limb of the letter, as seen in the following diagram.

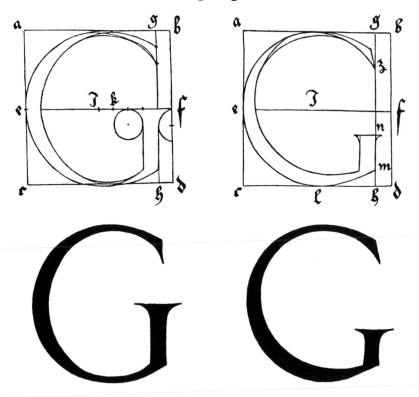

The letter H is to be formed of two broad, great, & vertical limbs of the height of the square, in such fashion that their extremities, being produced exteriorly, shall touch the four angles of the square, a. c. and b. d. respectively. Now in what fashion the projections of the broader limbs of letters are to be rounded out at top and bottom and on either side, you have been instructed; for in any letter you please, any broad and vertical limb is to be depicted at top and bottom thrice as broad as at its middle: provided always it is not joined to a narrower limb. So when this has been accomplished, then draw your narrower transverse limb upon the line e. f. as is shown below.

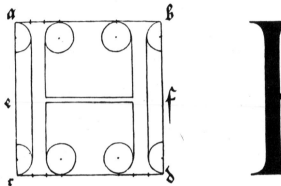 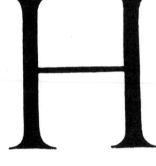

THE LETTER I.

The letter I you are to make of a single broad vertical tract in the midst of its square, touching the latter top and bottom; and of this, at both ends, and on either side, you are to round out the productions or projections as below is shown.

 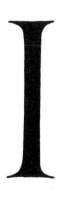

THE LETTER K.

Now for K: You are to make the first tract vertical, in the same man⁄
ner as you formerly did for H; then draw another narrower limb from
the broader and erect one, so that it may, at its lower end, impinge
obliquely on the transverse line e. f. and above may ascend to the right
till it meet the line a. b., taking care to make it parallel to the diagonal
c. b.; and this, at the top, you are to produce in both directions so that
each production may represent a tenth part of the line a. b. The hither⁄
ward projection you are to round out with a circle of which the dia⁄
meter must not exceed the breadth of the lesser limb; but of the other
arc, by means of which you round out the farther projection, you shall
make the diameter double as great as the diameter of the arcs by which
you have customarily hollowed out the preceding extensions of the
broad and vertical limbs. Next, from the narrow limb so constructed
draw in a downward direction another broad limb, so that it too may
be parallel to a diagonal of the square; & of this the beginning is to be
taken from the acute angle which the narrower limb makes with the
broad vertical limb, and let it be drawn with its projection to the angle
d., yet in this fashion: take two points this side of d. after this manner,
so that the first point may be distant from d. the tenth part of the line
c. d. & the second as far again from the first; then let the said tract be
drawn within the space which is between the two points, but in blind
and invisible lines. Afterwards you shall add the extension, which you
shall make this way: take before f. in the line e. f., a point g. no farther
distant from f. than the breadth of the narrower limb; on this point
set one leg of your compass, & let the other be extended to the angle d.,
from which let it be guided back along the broad but invisible blind
limb: thence will result the lower convexity of the tail you seek; but
its upper concavity look for in this way: divide f. d. in its middle point
h.; on this set one leg of your compass, and with the other describe an
arc passing through d. to meet the broad limb.

Or you may make K in this manner: First, let your broader vertical
limb, and your upper narrow one remain as they have been described,
except that the interior angle which the narrower limb forms with a. b.
shall remain acute, but the exterior one shall be rounded out, as has

been said. Then let there be drawn the lower broad limb, obliquely
from the angle which is included between e. f. and the vertical limb,
and let it descend to meet the side c. d. so that between d. and the limb
the width of the limb be left vacant; and the hither angle is to be left,
but the farther, towards d., shall be rounded out a little, as shown below.

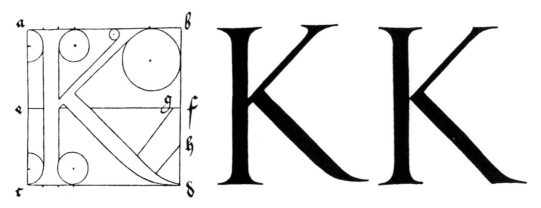

THE LETTER L.

As for the letter L, you shall make it by a combination of parts of
two of the preceding letters: namely, you shall make the first vertical
broad limb, as you did a while back in I; and to this join a foot as you
did at the bottom of E, when you made it. Such is L depicted below.

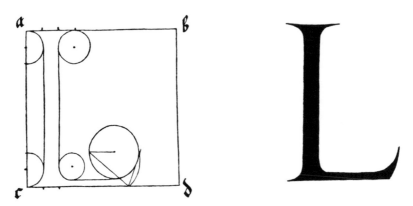

THE LETTER M.

The letter M you shall form in two ways within its square. In the
first, draw the narrower limb of the letter vertical, to the right of a. c.,
distant from a. one-tenth of the distance a. b.: draw the other, & broader
limb, on the near side of b. d., also a tenth part of the whole distant

from b. & in such fashion that both limbs touch the square at top and bottom; then, between the two, bisect the line c. d. in the point e. and draw a broad limb from the inner angle of the narrow limb, downwards to the point e., & next a narrow one upwards from e. to the inner angle of the broader vertical limb; and the inner angles at top you must not round out, but leave acute; the exterior angles, however, at the top, and both exterior and interior at bottom of both vertical limbs, you are to adorn with the customary projections, as you have done in the preced⁄ing letters. You are to know, too, that when these letters are drawn with a pen, they are to be described with a single stroke. But for your guid⁄ance is this letter, in the manner in which I have instructed you, de⁄picted below.

<div align="center">Another method.</div>

Another way is thus: Divide the side a. b. of the square into six equal parts & mark off the two extreme parts, one at either end, by the points f. and g.; then draw the inner and broader limb, with its point at e. as above; and to this, in an upward direction, a narrower one, so that be⁄tween f. g. be left a vacant space, and so more readily the letter slope forward. Then you are to draw the two lateral and vertical limbs—the near and slender, and the farther broad one—at the top, indeed, as in the first sketch, but at the bottom produce them to the two angles c. and d. and finally add projecting cusps, as you were instructed in the first M; but the projection below will pass beyond the square at the points c. and d. Or you shall make M at top with acute angles, in which case the lateral limbs will slope the more; or shear them off obtusely, and in this fashion (whichever pleases you best) make them as you see them depicted in the following diagrams.

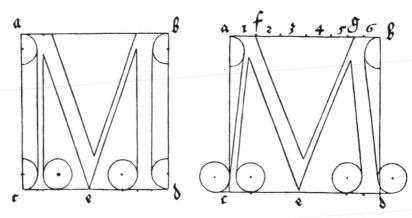

MMM

THE LETTER N.

Likewise the letter N you shall make in its square thus: First you are to draw two standards vertical and slender, so that at top & bottom they may touch the square, & that being produced, the nigh one at the bottom, and the farther at the top, they may touch the angles at c. and b. Now join these two by a broad oblique limb, running from the angle a. to the point e., by which is denoted the remote side of the farther limb, where you shall allow the acute angle to remain; but at the top, this limb, produced beyond the angle a., you are to round out to a fifth part of the length of a. b. This prolongation should incurve below, a fifteenth part of the distance a. b. projected on two arcs, the upper one the greater, the lower the less. For the lesser arc, therefore, you shall take as diameter of its circle, a line the fifth part of the distance a. b. and its centre is to be taken outside the square, so that the foot of the compass may touch the tip of the extension and the angle a.; then ex-tend a little the feet of the compass, and shift its centre until the arc touch both the tip of the part produced, & the broad oblique limb, in the middle point between the side a. c. & the nearer of the two slender vertical limbs.

Or you may make the letter N in such fashion that its upper nigh extension shall remain within the square; or you may make from it an acute angle as shown overleaf.

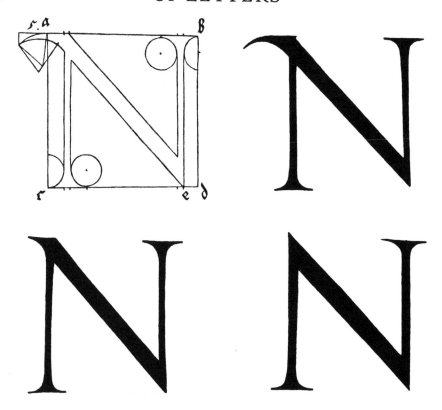

THE LETTER O.

Now O you shall make this way in its square. Set in the square the diameter c. b. and bisect it in the point e., so that e. may form a middle point between the two points f. and g. which are to be your two cen‚ tres; and from each let a circle be described touching two sides of the square; & where the circles cut one another, there with your hand you must shape the slender outline of the letter to a juster proportion, as below is shown.

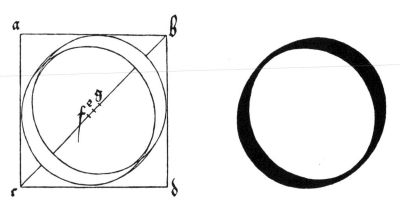

THE LETTER P.

P you shall make in its square in this wise. Divide the square a. b. c. d. by the median horizontal line e. f.; then divide a. e. & b. f. equally by the line g. h. Next draw, first the broad vertical limb for this letter P, as you did a short while ago for K, and afterwards erect the line i. k. the distance of its own breadth to the right of your vertical limb; (here you must ever observe that in a lettered square we speak of the angle a. as the "hither" angle, that is, to the left; & the angle b. as the "farther" angle, that is, to the right). Then where the line i. k. cuts g. h. call the point l., and next draw two slender horizontal limbs, the upper below a. b., the lower above e. f., from the broad vertical limb as far as the line i. k. Set one leg of the compass on the point l., extending the other to the lower side of the lower horizontal limb near k.; then describe an arc through the line g. h. as far as the other slender horizontal limb of this same P, & where it cuts the line g. h. set the point m. Next, on the far side of m. measure the width of the large limb of the letter, along the line g. h. to the point n. and let your compass be stretched so that with one foot it may touch the line a. b. and with the other the point n.; then set one foot of the compass on n. & the other on the line g. h. to the right, in the point o., in which this foot is to be left standing im⁄movable, and with the other is to be described an arc, passing through the point n. and touching the lines a. b. and e. f.

Or you may form the loop of this letter in the following manner. Set a leg of the compass under the transverse g. h. in the line i. k., in a place median between the line e. f. & the lower part of the upper trans⁄verse of the slender limb, in the point p. and describe an arc as before, passing through m. so that the loop will be acute at the bottom, and its tip will end in the middle space between the line i. k. and the broad vertical limb of the letter.

Or make this same P with a circular sweep, by shifting the compass upon the diameter, so that that sweep may be broader at the top (as though made with a pen) as will be shown in the diagram on the fol⁄lowing page.

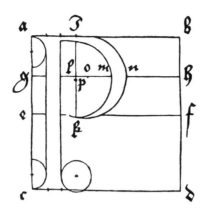

THE LETTER Q.

Make your Q in its square in the self-same manner as was pre-
scribed for O; but add to it its tail thus: Draw a diameter of the square,
the line a. d., about which, starting from the curved outline, begin to
draw a long tail, producing it through the angle d. in such fashion that
d. may be in the middle of the thickest part of the tail; but where the
tail begins let it be a little narrower than in the angle d., where it should
attain its real thickness. Then let it be drawn out, beyond the angle d.
to the length of the entire diameter, and in a downward direction, yet
so that it curves while it slopes, & that its tip shall not fall lower than
a third of the side below the lowest side of the square, and shall tend,
as it nears the point, to grow sharper little by little, and at length end
in a very fine point indeed.

Or you shall give Q a shorter tail in this fashion, to wit: set your
compasses to the length of the side c. d. and draw a tail from the bulge
of the same letter, describing through the point d. its inner arc of the
same length as c. d., taking care that the tail bend upwards until it again
reach c. d. produced, in the point h.; then shift your compasses, & with
the other leg again describe from the bulge of the letter an arc below
d. & continue it until again it reach h., but in such fashion that the tail
shall find its greatest thickness at the start, as in the following figure
is doubly depicted.

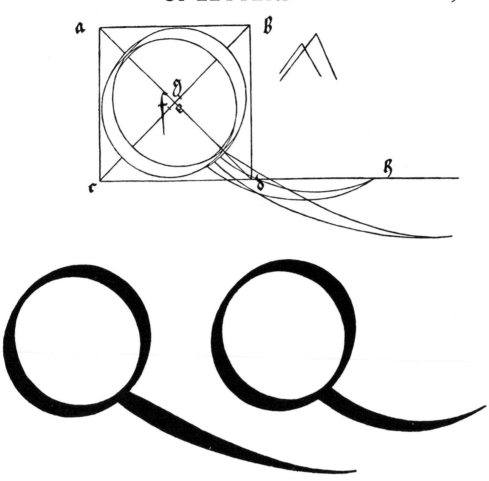

THE LETTER R.

Moreover R you must make in its square just as was directed for P; but then erect a right line q. r. through the middle point of the square, & let it cut the exterior arc of the rounded limb in s., from which point, downwards towards the angle d., let there be drawn a broad tract, almost equal to that which you made above for the letter K., but this is to be somewhat bent in, and so shaped by your hand that its tip, well formed, may arrive directly on the angle d.

Or make R in such fashion that its rounded sweep, as though made with a pen, shall be above broader, & narrower below. To accomplish this, you must shift your compasses on the diameter q. e. & not allow the rounded limb to touch the vertical one, as was described in P. Besides, the oblique limb is to be deduced from the rounded one with a little more of a curve; just as I have drawn overleaf.

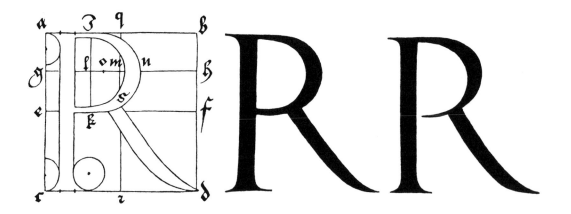

THE LETTER S.

Next, the letter S you shall make as follows in its square, a. b. c. d. First draw the horizontal line e. f. and the median & vertical one g. h. and let them bisect one another in the point m. Then choose the main thickness of the letter, and set it in the line g. h. so that the point m. may divide it, having one third of the thickness below it; next, set the lesser thickness, at the top beneath g., indicating it by the point i., and at bottom, above h. in the point k.; and the thickness of the letter in dicate above by n. and below by l.

Next, set a leg of your compasses on the line g. h. in the mid point between i. and n., and with the other describe a circle passing through i. and n.; in like manner, upon the line g. h. set your compasses upon the mid point of g. l. and describe a circle passing through g. & l. Then once more set your compass on the same line g. h. in the mid point of n. h. and describe a circle through n. & h.; and lastly, in the mid point of l. k. you must set one leg, & with the other is a circle to be described through these same points l. & k.; afterwards cut off by vertical section the upper portion of this letter, so that the part thus cut off may con tain in its extremity the maximum thickness of the letter and a third part besides, & also that its tip may project downwards so far as to stand midway between the centre of the circle i. n. and the side b. d.; in other words, let the tip be distant on the right, from the circle i. n. the first third of the interval between the greater and lesser circles.

Next cut the lower limb of the letter to the left, by a vertical line through the mid point between the two circles, & in such fashion that

the part so cut off may be a fourth part wider & higher than the upper, and that its tip may rise to the height of the centre of the circle n. h.

Another method.

Yet another way may you make the letter S. In the square a. b. c. d. bisect the horizontal line e. f. in the point m.; then set one leg of your compass upon the mid‑point between g. and m. & with the other de‑ scribe a segment of a circle in the direction of a. e. passing through the points m. and g.; next, set your compass upon the mid‑point between m. and h. and describe a segment of a circle through m. and h. in the direction of f. d. The two arcs will touch above, in front, and below, in the rear, the exterior curvatures of this same letter S.

Next, draw through m. the diameter c. b. and at its middle indicate the maximum thickness of the letter by the two points p. and q. from which let there be drawn two right lines, one up, & one down, to those two arcs; & next, from the two points p. & q. draw two curved parallels to the same arcs, regulating the distance between them, their elevation & depression from the centres of the same circles. Next, indicate below g. and above h. the minimum thickness of the letter; and from these points you will with your hand fashion the inner shape of the letter, both above and below, & produce the limb of S, above towards b. Cut it off so that its lower tip may touch the segment, & that the part cut off upwards may contain a tenth part of a. b. and that the segment may still exceed the part cut off. Then construct a vertical line r. s. to the right of e. c. and distant from it a fifth part of c. d.; let it cut the dia‑ gonal c. b. in t. and to the angle just formed produce the extremity of the letter, making the part so cut off a third broader than the upper por‑ tion. Lastly, you will have to produce the tip ever so little beyond t.; as I have briefly indicated.

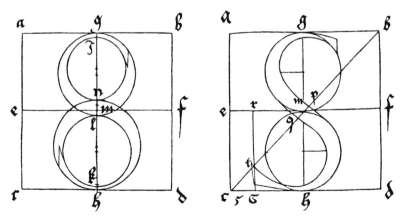

S S

THE LETTER T.

Set the broad limb of T in the midst of its square erect, produced &
drawn to a point on either side below, just as you did before in the letter
I; then take two points e. and f., distant respectively one-tenth of the
whole space from a. and b., and let the transverse limb of the letter be
drawn below e. f. and of an equal length with it; but the projecting ex-
tremities of this line are to be cut obliquely, and the tips of these pro-
jections shall so far extend above the line a. b. to the right as below they
depend to the left. The oblique lines of these projections are to be each
a fifth part of the length of a. b.; & the angles of these projections you
shall round out by means of circles of diverse radius—namely, for the
lesser angle you are to use a diameter only two-thirds of the width of
the broader limb; but for the greater angle you shall take a diameter
equal to the side of a square contained between the broad and vertical
limb and the intercepted portion of the line a. b.

Another method.

Or you make T thus in its square: Take your point e. as before, to
the right of a., and cut your transverse limb diagonally, as before, yet
so that the projection be dimidiated to the right, and at top the angle
remain as it falls; and so at the other extremity, only the point f. must
be moved as near again to b., the cutting line to be a little more erect,
& the projection formed a trifle broader than at the hither end; other-
wise shall everything remain as before; as I have delineated for you on
the opposite page.

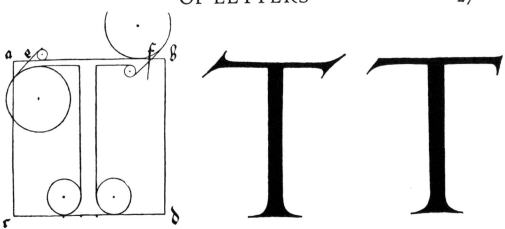

THE LETTER V.

V you shall thus make in its square: Bisect c. d. in the point e.; then set the point f. one-tenth of the whole line a. b. beyond a., and in like fashion g. to the hither side of b. Then draw the broad limb of your letter downwards from f. to e. and sharpen it; & thence draw upwards your slender limb to g.; and at the top produce it in either direction, as you did before at the bottom of A; just as you see it shown below.

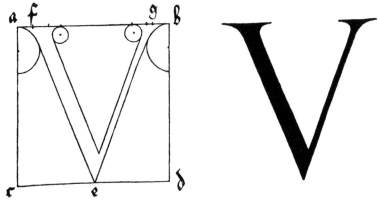

THE LETTER X.

X you shall form thus: Draw two vertical lines e. f. and g. h. distant respectively one-tenth part of the line a. b. from the sides a. c. and b. d. Then draw the two limbs intersecting one another in the form of a cross—the broad one so that at top, & with its hither side it shall touch e., & at the bottom, and with its farther side h.; but the narrow limb so that at top, and with its farther side it may touch g., & at bottom, with its hither side f. Then add its projections, touching, at top and bottom, the four angles a. b. c. d., & choose a semi-diameter of the larger circle

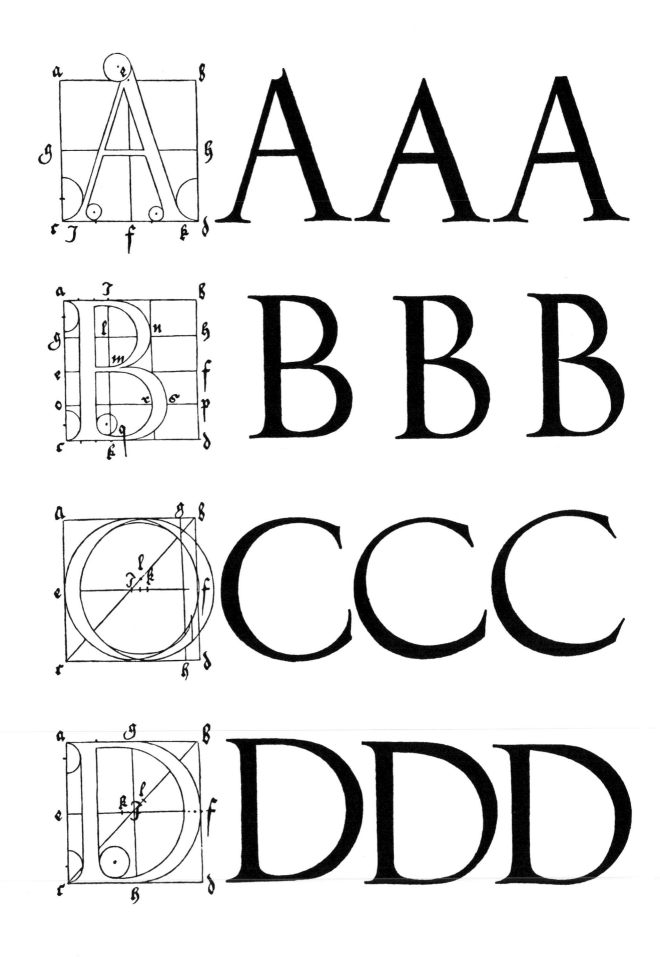

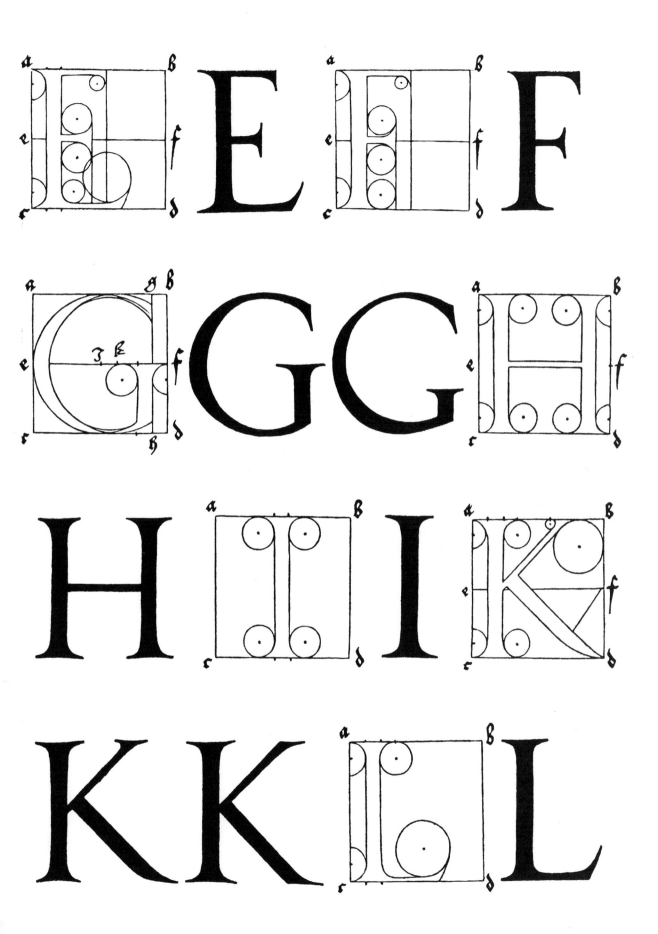

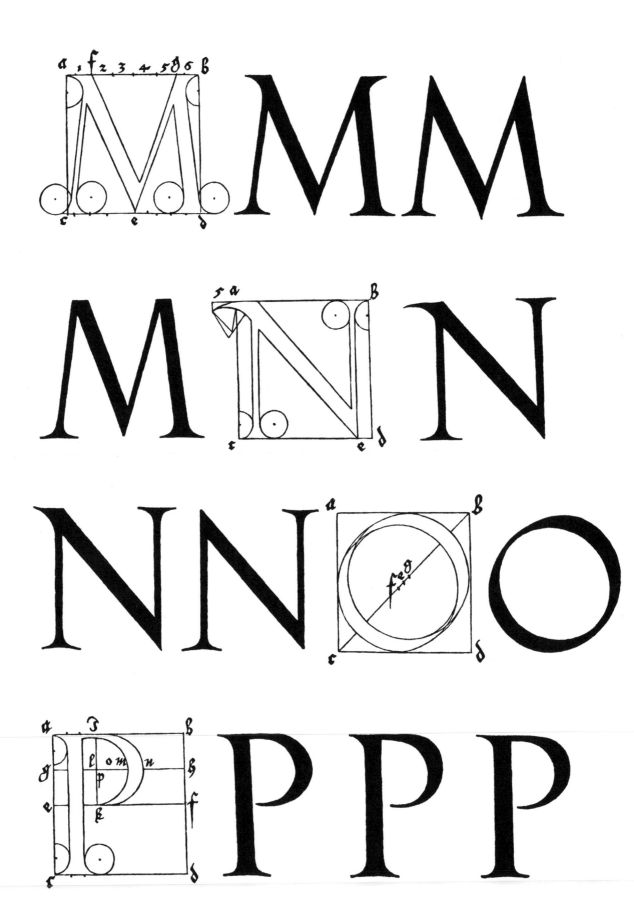

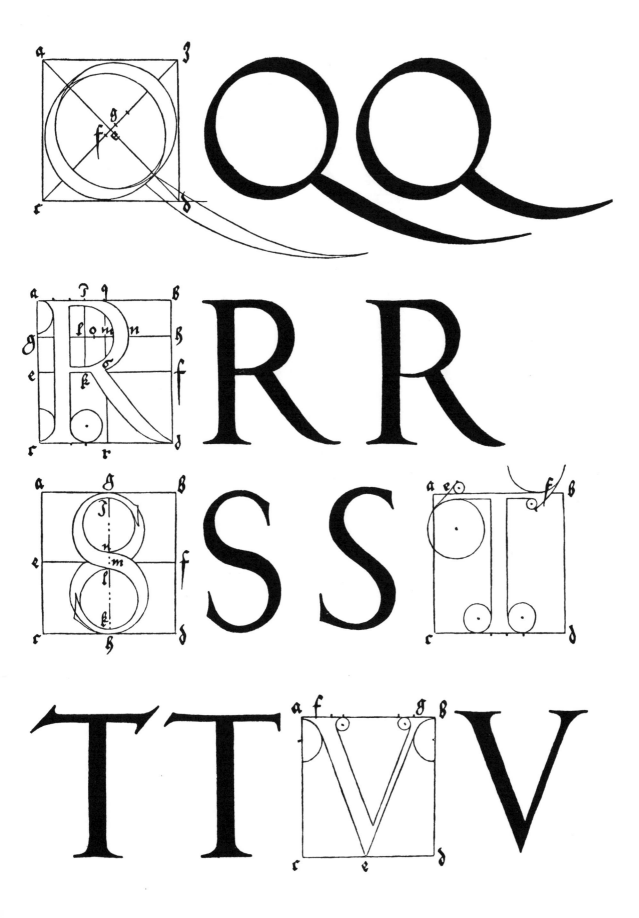

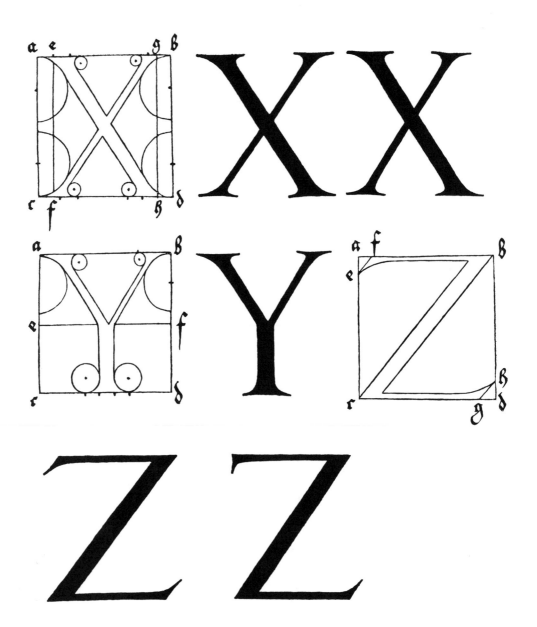

DIRECTIONS FOR THE CONSTRUCTION OF THE TEXT OR QUADRATE LETTERS

THE letters which are usually called "text," or quadrate, it was formerly customary so to write, although they are now imitated by the new art, as presently I shall show below. Although the alphabet begins with the writing of A, yet shall I (not needlessly) in the first place undertake to draw an I; because almost all the other letters are formed after this letter, although always something has to be added to it or taken away.

First make your I of equal squares, of which three are properly set one over the other; and the top of the top one, and the bottom of the bottom one, divide in two points, that is to say, into three equal parts: then set a square equal to the others in an oblique manner, so that its diagonal be vertical, and its angle on the first point of the top square. In this way, this oblique square shall extend with its angles more to the left than the right. Then produce upwards on either side, after the width of the superposed squares, right lines to meet the sides of the oblique set square. Next do below precisely as you did above, except that you must set the angle of the oblique square on the second point, that is, the one farthest to the right in the bottom of the lowest square; and let fall your lines on either side upon the transposed square: so will I be perfect; only above it draw with a fine pen a tiny in-crescent.

So shall you make N from two standards of this same I, set so that their angles at top and bottom touch; and in this manner the space between the two shall be narrower than the breadth of either: also, you shall no longer put little crescents above them; you must make of the same length all the short letters throughout the alphabet.

In like manner make M of three standards, just as you made N of two.

R make as I, except only that at top you must set an equal square diagonally, to the right, so that angle touch angle. R you may make also in this fashion: below leave its foot as before, but above add two diagonal squares, which shall touch each other with their angles in the

middle point of the vertical limb, and then produce upwards both sides of the latter to meet the diagonal square.

V is made in three ways. First let it be made simply, as N; only that in the farther limb, you shall omit at the top the diagonal square; and instead shall draw an oblique line, so that it may make two angles in this limb (produced) of which the farther shall be of the same height as that of the topmost angle of the diagonal square, & the nigher angle of the same height as the angle nearest to it in the said square.

The second V, which we use at the beginning of a sentence, make thus: Draw the first limb as before for I; only, at the bottom, push the diagonal square a little further to the right, so that its hither angle does not project beyond the side of the vertical limb, but falls in the line of its descent. Then set the second limb to the right of this, and cut it off below by an oblique line, drawn from the lowest angle upwards to the right, as far as the middle point of the lowest of the three superposed squares.

Next make W (i.e., double V) just as you made V-simplex; only you shall set before it the standard limb of I.

B make as the second V-simplex; but in the first upright omit the diagonal square at the top, and set upon the three original squares three others similar, but the seventh one you shall cut off diagonally from its lower hither angle.

Likewise when your B so made is turned upside down, then it will be a Q.

X you shall construct from I. Append from top angle to the right a diagonally set square, as you did before in R; and at the bottom draw an acute tail to the left from the diagonal, and at the middle of the ver-tical limb describe a transverse, in such way that the former is cut before and aft by the latter's diagonal; let the hither and lower angle be termi-nated as far in front of the upright as would measure one-half of the cutting diagonal, which at top shall just touch the upright; but to the right let the transverse at top project to a point just below the angle of the oblique square; from thence downwards let it be cut off by an ob-lique line parallel to the anterior diagonal.

C you shall construct from I after this fashion: Remove the top dia-gonal square, & let lines be produced on either side to the proper height of the letter, and cut off the hither angle by a diagonal; then draw at

top a broad transverse, projecting beyond the vertical to the right the width of the latter, and cut this off by a diagonal in such a way that it project below only half as far as above.

The vertical standard of E you shall make as for C; but from above let there descend to the right a broad limb from the diagonal bisecting the right angles of one square, and one-third again as long as broad; and let there be drawn from its lower angle a small diagonal line to the vertical limb.

T shall be made like C, except that at top something is added to its diagonal, so that its tip converges to a fine point, and the like to the left on the hither side of the broad standard, just as at the top: and because of this is T at top more elegant than C, and has not the same incurved appearance.

L you are to make below like I; only six squares are to be set on end; then cut off the hither side of the seventh by a diagonal, and so the apex of the letter shall remain to the right.

The letter S you shall make as L; except that at top to the right must be drawn a broad limb of the length of the diagonal, which afterwards you are to cut off by a line parallel to the diagonal.

F you shall make as S, just adding to it a transverse limb at the height of the shorter letters and double as long as broad, so that the point on the hither side & below shall project as far as half the limb's breadth, so that the two diagonal abscissions may be equidistant from one another.

The near limb of the letter H make like L, and to it join by its top, in the proper place, the farther made like I; but below, for the diagonal square, substitute a fourth square in line with the others, and the fifth and lowest cut off on the far side by its diagonal.

Of K make the near limb like L; and to the right of it append a diagonal square, from the lowest angle of which let a line be obliquely produced to meet the said vertical limb; and next from this line let a broad limb be obliquely drawn, and this, at the bottom, you are to cut off by a diagonal, in such fashion that the space below, between the two tips shall not be more than the diagonal of a single square.

D in its lower half make like B; but at top let the anterior limb ascend upwards to the maximum height of the letters, and then cut off the hither angle by its diagonal; next superpose to the same height half a square upon the other three squares of the farther limb, & once more

do here as you did below, and let this broken limb rest on the angle of the near limb, and let it extend beyond it as far as the end of the up/right near limb; and so will it all but contain three conjunct squares; for when it meets the near vertical limb, that fraction is to be cut off at right angles.

O you are to make below as D, and also the same at the top as the bottom, only, as it were, turning it upside down.

The anterior limb of P make like L inverted; but the posterior like the standard of I: at bottom, however, you are not to add an oblique square, but amputate the limb diagonally, & draw at the bottom a broad transverse limb, which likewise is to be cut off diagonally, so that the lower point shall project to the left, a distance of half the breadth of the limb.

Likewise A in the lower half you are to make like N; but of its an/terior vertical limb, you are to cut off the hither angle of the middle square by its diagonal; of the posterior, however, allow three squares to remain superposed, and incline the top part (the fourth square) rather to the left, so that if at this side is joined to it the half of a square, then it shall attain the height of the letter; and cut off the square obliquely, yet so that the lower point shall project farther than the upper; then describe to the left a circle, sweeping downwards, so that its contents shall embrace the farthest limit of the anterior limb.

Z is made in threefold fashion. First set a diagonal square which shall touch the height of the letter; then add another like it, on the right, joining their sides, & let these form a quadrangle sloping down/wards on the right: next set a diagonal square in straight line under the top square, and distant from the lower one the length of its diameter: then draw a diagonal line between the near angles of these two squares, or make a rounded limb to reach the lower square; but from the said lowest square of all you shall draw downwards and to the right, by the aid of divers circles, a round extension, whose bottom shall mark the length of the letter; and let its tip, sharp and tenuous, verge to the left. Or construct Z of three oblique limbs, one above the other, & to con/nect them draw the diagonal, which shall slope upwards to the right.

Another Z you may make in this way: Let three diagonal squares be set atop of one another; and let the lowest have a rounded extension, as in the first Z.

The first limb of G make below like I, and add at the bottom another diagonal square, joining the two by their angles; but at top produce the farther tip of this limb upwards to the height of the letter, & from this point draw a diagonal downward to the left, as far as the hither angle of the first right square of the three set one on other. Next draw the farther vertical standard entire, of the same length as the hither standard, and at the bottom draw a diagonal from the angle of the lowest oblique square to touch the tip of the angle of the farther limb, & on the inner side produce downwards the side of the limb, to meet the tip of the said diagonal; to this also, by one line, join the lowest of the hither squares. Now draw at top a transverse limb of the customary breadth, from the back of the nearer vertical limb, passing through the farther one, and reaching as far beyond this as its breadth; & this limb, finally, you shall cut off by an oblique line parallel to that of the near limb.

Y you shall make as N, only at bottom must be omitted the farther diagonal square, & in its place is to be set a right square under the other three superposed squares; then split the fifth square by a diagonal, so that the tip shall be in front; from which let there be produced a dia⁄gonal line, equal in length to a single side of the square.

Curved, or short S, you shall make on this wise. At the middle height of the letter, let there be set, close to one another, their angles touching, two oblique squares; from the near square draw a broad vertical limb to the height of the letter; and in the same fashion, from the farther square let one fall downwards—just as you constructed I top & bottom. Next cut off both these limbs, one at top and one at bottom, by dia⁄gonals, in such fashion that the sharp tips of both may be on the side near the middle. Then let there be drawn two broad limbs—namely, from the upper, to the right, and downwards; and in like manner, from the lower, upwards, and to the left; of the breadth of the limb, above and below, but let them be produced no further than the breadth of the distance between the limbs: then draw a diagonal downwards, from right to left, which shall cut off both oblique limbs. To it also you must produce the sides of the squares set in the midst.

So, accordingly, have I set them down—in skeleton in rotation, and in proper order in black. This (as I said above) is the antique form of the letters; but in these days there is used a more elegant text, and a diagonal square is substituted in the middle place for a right square, so

that the lines of the letters are not so much curved; and there are made
certain limbs adjoined and cleft; and there are set one on another three
squares & a half; and spaces are left between two limbs as great as their
width. Letters of this sort also have I set forth on the third page follow,
ing; as also capital letters, which are called "versals," because
they are customarily set at the beginning of a verse;
and these ought to be made one,third
higher than the remaining
shorter letters in
writing.

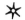

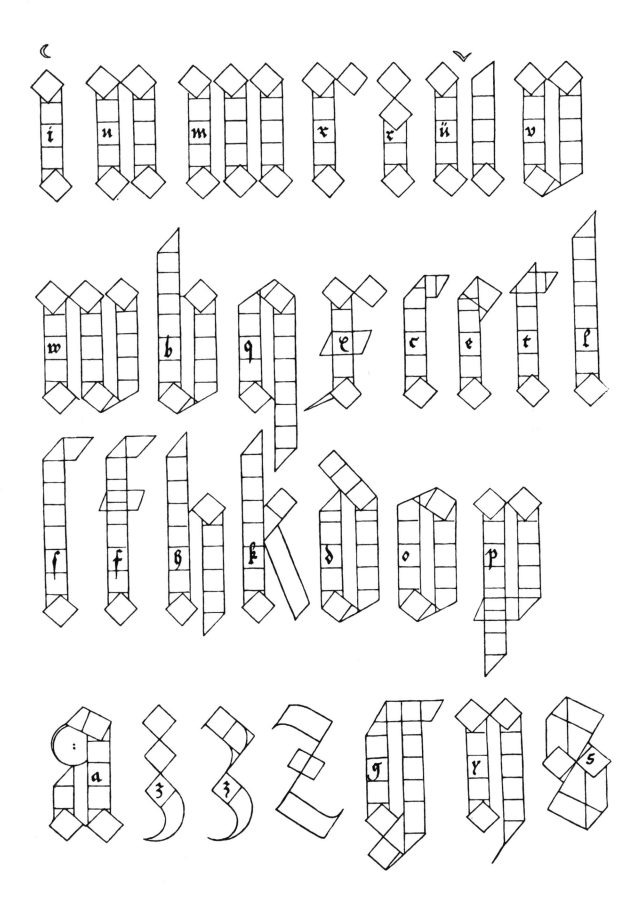

abcdefgh
iklmnop
qrilstuv
wxyz33z

Here ends this little Book.